MASTERPIECES OF THE SEA

WILLIAM T. RICHARDS

A BRIEF OUTLINE OF HIS LIFE
AND ART

BY

HARRISON S. *smith* MORRIS

UNITED STATES COMMISSIONER GENERAL TO THE ROMAN ART
EXPOSITION OF 1911, ETC., ETC.

WILLIAM T. RICHARDS IN HIS STUDIO AT "GRAY CLIFF" (ABOUT 1895)

PAINTED BY ANNA M. RICHARDS, HIS DAUGHTER, NOW MRS. W. T. BREWSTER

THE MARINE VIEW ON THE EASEL WAS PAINTED IN THIS PICTURE BY MR. RICHARDS HIMSELF

WILLIAM T. RICHARDS
MASTERPIECES OF THE SEA

WILLIAM T. RICHARDS
MASTERPIECES OF THE SEA

PRINTED BY J. B. LIPPINCOTT COMPANY
AT THE WASHINGTON SQUARE PRESS
PHILADELPHIA, U. S. A.

ILLUSTRATIONS

PAGE

WILLIAM T. RICHARDS IN HIS STUDIO AT "GRAY CLIFF"
 (ABOUT 1895)......................................*Frontispiece*

"WHERE TUMBLING BILLOWS MARK THE COAST WITH SURG-
 ING FOAM"... 8

STORM AT POINT JUDITH, R. I............................ 10

GUERNSEY CLIFFS, CHANNEL ISLANDS....................... 12

TANTALLON CASTLE, NEAR BERWICK, SCOTLAND............... 16

BREAKERS... 20

MID-OCEAN.. 22

WILLIAM T. RICHARDS.................................... 26

MRS. WILLIAM T. RICHARDS (ANNA MATLACK RICHARDS).. 26

FEBRUARY... 30

BREAKERS NEAR THE DUMPLINGS, CONANICUT, R. I....... 36

A REEF NEAR NEWPORT, R. I.............................. 36

CATHEDRAL ROCKS, ACHILL ISLAND, WEST COAST OF
 IRELAND.. 40

BREAKERS AT BEAVER TAIL, CONANICUT ISLAND, R. I..... 44

SACHUEST BEACH, NEWPORT, R. I.......................... 50

"WHEN THE FLOWING TIDE COMES IN"....................... 50

THE YELLOW CARN, KYNANCE COVE, CORNWALL, WALES.. 54

ON THE COAST OF NEW JERSEY............................. 58

WILLIAM T. RICHARDS
MASTERPIECES OF THE SEA

I

I have passed so many pleasant hours in the company of Mr. Richards that the sweet and strong personality has almost replaced in my memory the claims of the distinguished artist. He used to come in to see me for a chat of half an hour or more, and he would discourse on so much that was delightful, yet outside the pale of his art, that I sometimes forgot, and still forget, that the kindly, intellectual gentleman was also a masterful painter.

He would enter almost shyly, so modest and quiet was he—a short, slight frame, little in keeping with the great forces he evoked in his work. He was clad in demurest colors and often wore a soft black hat dented at the top, which crowned his benign white hair as an artist likes. There was nothing of the pose of his craft

7

about him, no eccentric hue or fashion; and yet his manner, the cast of keen observation in his face, and the easy grace of his carriage, denoted the man of original thought and unconstrained opinion, the artist who sees a little deeper into objective life than most people, and whose instincts are, therefore, less confined to convention.

No tame acceptance of authority was his; he thought for himself in his gently self-reliant fashion, and he had evolved a tranquil philosophy that was drawn both from just perception and wide reading.

And the face below the hat—what sweet serenity of expression; what goodness, that would laugh at prudery but sympathize with its limitations; what tolerance and friendliness and acceptance; what invitation to intercourse, and what understanding of human needs! And yet, however much the feelings and heart may have been moved, within that face there was no grief and bitterness; no vain impulses hurried it; no ambition ruffled

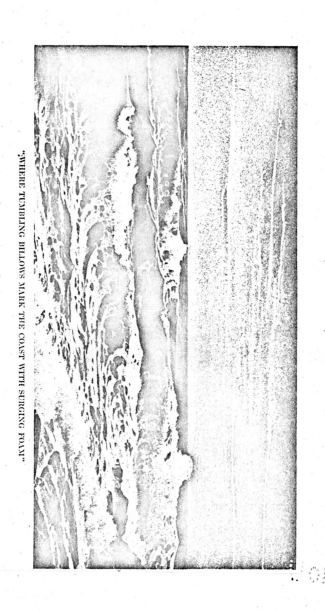

"WHERE TUMBLING BILLOWS MARK THE COAST WITH SURGING FOAM"

its surface; only love, that was manly and unassertive, and human kindness and intellect that ran into smiles and quiet laughter, or into clear receptiveness. Rarely have I seen so sweet a masculine countenance in the maturity of white-haired age, as was his.

And yet he was a shrewd and careful manager of his own fortunes. He had an uncommon grip on those affairs in his career which brought his elder years into competence and substantial comfort. He well knew the worth of his canvases, while always denying them the too great qualities assigned by others. He always modestly put praise aside with an apt estimate of his own talents. He knew he could draw matchlessly, and yet there were elements in the portrayal of a breaking wave that he had never achieved to his own satisfaction. If you pressed him with commendation on the side of drawing he would shield his modesty behind his struggles with that miracle of color under the curving wave. He had studied this for years. His son tells us

9

that " he stood for hours in the early days of Atlantic City or Cape May, with folded arms, studying the motion of the sea,—until people thought him insane.. After days of gazing, he made pencil notes of the action of the water. He even stood for hours in a bathing suit among the waves, trying to analyse the motion." He could paint the action and color of the water more faithfully than most artists, and his rendition of it was an inspiration to untrained eyes; but he believed that there was a level of truth above his execution, and he kept his youth alive to the end in following this ideal.

His alertness in the business of art was not incompatible with the most unflinching adherence to his standards of perfection. His old friend, Mr. W. H. Willcox, tells an anecdote of a one-time celebrated picture by Mr. Richards which illustrates this. " He painted," says Mr. Willcox, " a blackberry bush in the open air, which almost everybody conversant with art in Philadelphia at that period still remembers. Mr.

STORM AT POINT JUDITH, R. I.

J. R. Lambdin made a sketch at the same time, not far from where Richards was working. A boy, looking at Lambdin's picture, said: 'Mister, how long did it take you to make that?' Lambdin mentioned a few days, when the boy said, 'Good for you; that fellow up there has been all summer over his.'" In further illustration of the trait in question, Mr. Willcox tells us that "the picture was not more than twenty inches long, but it made a marked impression in art circles, and sold for six hundred dollars. Subsequently the owner became financially embarrassed, and asked Richards to sell it for him. Richards replied by promptly taking it off his hands at the same price. Richards probably knew that he never would do that kind of thing again, and wished to retain it. But it finally cracked, though the faithful work on it is still visible."

His eldest daughter, Mrs. William F. Price, also has in mind his unfailing standards when she says: "Concerning this time he used to tell a story of his

young friends and fellow artists. Mocking and jeering at his industrious ways, they would come in on pleasant summer afternoons when he was either working busily to finish a picture or preparing to go out sketching, and beg him to go with them on some pleasure trip. He was an old fossil, they declared, and would never get anywhere in the world if he stuck so fanatically to his work. 'To succeed you must be a man of the world,' said one, who was later, alas! a tragic and pathetic failure. Of the others none in any way approached his success, but for all of them he kept an unabated and loyal friendship."

Perhaps the trait of self-preservation which is so often omitted from the equipment of artists, and which in the early days of Mr. Richards' youth was conspicuously so, may be of kin with the capacity to see justly, which Mr. Richards had in a marked degree, and which so many of our earlier painters lacked. He could see the details of the blackberry bush with unerring power,

GUERNSEY CLIFFS, CHANNEL ISLANDS

and he could, even early in life, take note of opportunity with foresight and courage that yielded him the freedom his art required. He knew his strength very justly, and he shrewdly relied on it. Mr. Willcox says: "He amazed me by getting married and resigning his position as designer in order to devote himself entirely to his art. I don't remember which event took place first, but I thought the latter extremely unwise—and so it would have been with anyone else, but timidity had no place in his nature."

All this denotes a touch of life beyond the monopolizing palette, and in the same vein lie the wide sympathies with other intellectual currents which made Mr. Richards' company so alluring. He was apt in all the pleasant devices of conversation, full of humor and quiet laughter, full of diverting stories from his travels and his contact with life in many countries, and full of that large acquaintance with books that furnishes a ripe mind with overflowing talk. His household was

always strewed with books and his memory was strewed with their varied contents. But his favorite subject, with me, at least, was poetry, and among poets, of Wordsworth. He would quote short passages—I remember, of the "River Duddon" sonnets—and other beautiful and tranquil things, and talk on and on, lying back easily in his chair in the fullest enjoyment of the subject, until this would lead him to, perhaps, religion and creed and dogma, when he would utter those independent views of his in well-chosen fluency and show the fuller deeps of that ripe and original mind which had found so many secrets of the land and sea.

Even in youth this sympathy with every form of intellectual thought and work was evident. Thus he became one of the active members of "The Forensic and Literary Institute," formed of young debaters, several of whom afterwards made fame. One was Frank R. Stockton, the humorist and story-teller who invented "The Lady or the Tiger"; another was his brother,

John D. Stockton, of the *New York Herald* staff;
Judge James T. Mitchell, of the Pennsylvania Su-
preme Court, was a member; and Professor George
Stewart, of Haverford College; the Rev. J. Spencer
Kennard, and Judge Ashman, of the Philadelphia Or-
phans' Court, were others.

In the fullness of time, the independence of judg-
ment with which the eager young artist had started out
was shown in the blessed choice of a wife, and in the
events which brought fulfilment and made a home never
to be forgotten by those who knew it. We are told that
Dr. Matlack, the father of Mrs. Richards, was not
easily reconciled to the marriage of his daughter with
an obscure young artist, whose career might lead to
trials and severities. But the young man was resolute
and met the elder with a firm front and a determina-
tion which, while not melting the stern old Quaker, who
perhaps looked upon art as an immorality, was not to
be put aside. The marriage took place in spite of the

interview, and a long career of brilliant success justified the step and reconciled opposing views. It was, perhaps, this self-reliance and quiet courage of attitude toward daily life which gave the slender frame, the unadventurous cast of mind, a bias for painting the most savage seas and the most overpowering cliffs. It was always a problem to me why this small, quiet gentleman should have found his joy along the wildest of coasts. We associate the big muscular man with such employment. But Mr. Richards, light and delicate of mould, was fascinated by the grim scenery of Tintagel and Staffa and loved the cliffs he found in Maine and Rhode Island.

Indeed, it was he who first built a house on the bare granite front of Conanicut Island opposite Newport, and it is told of him that he was one day painting on this rugged shore when a tidal wave rolled in and almost carried him back with it. I do not remember to have seen him swim in the salt, though he

TANTALLON CASTLE NEAR BERWICK, SCOTLAND

may have done so when he was younger, and I am told that he knew how to swim and taught his children to do so, but he never learned to sail a boat, and rowed only in a most unprofessional way.

His love for the sea was not of the physical order. He had no desire to overcome its force, but he could subdue it to his brush, and it was perhaps a sense of this which stimulated his passion. He felt his mastery and he loved its object.

II.

William T. Richards (the middle initial standing for Trost) was born in Philadelphia on November 14, 1833. I know little about his early education, nor about the family traits that may have inclined him to art in an arid and unprofitable day. But Miss Fidelia Bridges, a pupil and life-long friend, tells of the unusual skill of his grandfather Trost, a Dutch goldsmith, from whom he may have inherited his manual dexterity and his phenomenal patience.

Sully was about fifty when Richards was born, and Stuart had died five years earlier, leaving the field to Neagle and Otis and Inman and the younger Peales; but by the time young Richards took up his brush these had passed, and their successors were mostly the " idle singers of an empty day." Thus he emerged upon a barren horizon, and he made for himself those opportu-

18

nities for study and association which are needful aids to talent.

I can do no better, from this stage of Mr. Richards' career, than give the outline of his early years furnished me, with characteristic kindness, by his friend and fellow painter, Mr. W. H. Willcox, of Germantown, Philadelphia. Mr. Willcox has thus, genially, set down his remembrances:

" My acquaintance with Mr. Richards began in the early fifties of the last century. At that time he filled a position in the firm of Archer, Warner & Miskey, manufacturers of gas fixtures and other ornamental work. Previous to this he was a boy in an Eighth Street store, and seeing an advertisement for a designer for the above firm he applied for the position. Some designs were given him to copy, which he did so well that he was awarded the situation, and when I first knew him, or soon after, he was receiving a salary of $1500 a year. His labors for the firm occupied nearly all his

daylight, but he followed the bent of his ambition by drawing on wood at night. I had seen some crude pictures which he exhibited at the Art Union Galleries, which adjoined the building subsequently occupied by the Earles, but was not favorably impressed. My preceptor, Mr. Isaac L. Williams, had made his acquaintance, and invited me to call with him, which I did. He was then living with his parents in the lower part of the city—about Bainbridge Street, I think. I had not formed a very high opinion of his ability; but his drawings quite astonished me, and I recognized his talent. There were few young men who aspired to paint in those days, and our mutual interest drew us together and developed into an abiding friendship. We went sketching together, and I counted much upon his criticism of my work. I remember our making studies of some fine old chestnut trees at what is now known as Belmont, but then as Judge Peters' farm, and each thought his own picture the best. He was almost as ambitious as

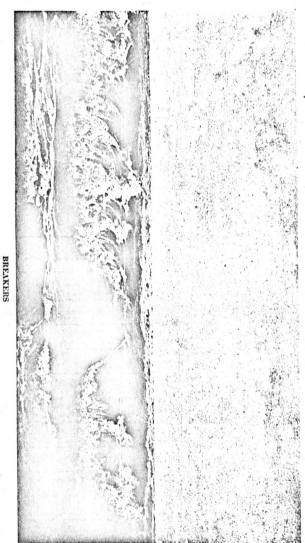

BREAKERS

a litterateur as he was a painter in those days, and with some chosen spirits established a club which they named 'Forensic and Literary Institute.' I had nothing to do with this. Long years after we made a trip to New York together and lay awake far into the night talking over our boyish experiences.

"After his marriage he removed his family to the country and I lost sight of him for a while. Later he occupied a studio in the Art Union building with Alexander Lawrie. Paul Weber was the most successful landscape painter in Philadelphia at the time and represented the Germanesque side of the art, and Richards was reported to have received instruction from him, but I have no knowledge of it, and never thought to ask him if it was true. There was, however, no indication of it in his manner of painting. Turner and English art were in the ascendancy, and Richards became an imitator of the former with large ambitious canvases of which the chief merit lay in the skilful drawing. This,

however, did not continue very long. One day I met him on Chestnut Street, and he told me that he had placed a picture in the studio of Mr. Hugh Davids, on Fourth Street, which he wanted me to see. I went and met Edmund D. Lewis there. To say that I was both surprised and delighted would express my feelings mildly. All the previous absurd Turneresque imitating had been thrown aside, and he had painted his subject directly and most elaborately from nature, spending months in its production. It was a complete revolution, and was the beginning of his future success. From that time on he ignored all fads and adhered to his own individuality.

"He had come to live in Germantown before this, first in Greene Street, then at the northeast corner of Mill Street and Market Square, from which he removed to Penn Street, near what is now Wakefield, where he lived many years, and painted some of his most remarkable pictures. I passed many very happy hours in this last house.

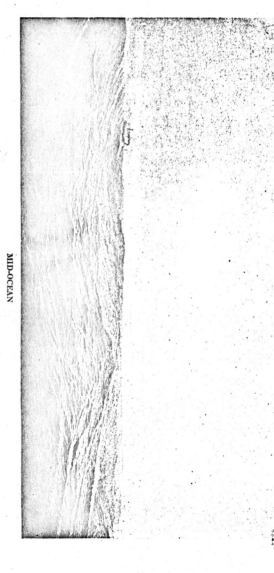

MID-OCEAN

"During this time he had become acquainted with Mr. George Whitney, who became a most enthusiastic patron, and for whom he did some of his very best landscape work. Nothing can exceed the wonderful painting of tree trunks in some of his wood pictures.

"During all this time I have no recollection of his painting the sea. His first efforts in this direction were remarkable for differing from the usual method of painting it but were indifferent in quality when compared with his later work, but he gradually gave his attention to it more and more, until the sea and coast occupied nearly all his time, his very best work being among his latest.

"Mr. Richards' removal to Newport in the seventies was for the express purpose of studying the sea and shore at home, and his wise choice was manifest both in his work and in his investment, for in addition to his talents as a painter, he was remarkably shrewd as a business man. He was also an indefatigable and prolific worker, which was rendered possible by his uniform

good health. He was intellectual in his tastes, affable in disposition, and though not particularly social in his habits, was a firm and true friend, whose loss will long be felt by those who enjoyed his intimacy."

There seems to be little doubt that the young fellow of fifteen or so, received instruction from Paul Weber, and it is probable that this able follower of the grand style in landscape was his first teacher. But as his powers grew and his knowledge of art and life expanded, it became necessary to add experience to teaching, and in 1853, Richards left the designing-room of the Archer & Warner firm and devoted himself exclusively to his art.

Thus he went on with such self-training and local aids as were available until he became of age. He then resolved to see more of the world and its stores of art than were afforded by the narrow vistas of Philadelphia, and with his accustomed pluck he set forth for Europe. This was no holiday adventure as now, when the big

steamers furnish a six-day ferry across the sea. It was a serious undertaking, especially if funds were limited, as was the lot of young Richards.

But, with a stout heart and confidence in his own talent, he sailed away from home, and visited Paris, Florence and Rome, where he spent a good deal of time with no express effect upon his painting; though contact with the work of the contemporary French and Italian schools was a vastly excellent discipline for a youth who had hitherto been influenced only by the lesser followers of those great men. He never spoke of receiving any ideas from such masters, but it was his aim to see at first hand what they were producing; and to an imaginative lad with ambition to succeed in painting, their methods and designs must have been deeply stimulating. Nor did his art show any effect from a closer knowledge of the great works of the Renaissance and antiquity. Yet the mental discipline must have been quietly powerful and as his drawing grew in precision

with his maturing talents it is not an extreme presumption to say that his native gift received, at this impressionable period of his life, its largest force from the knowledge of such perfection. We know how such a trip affected Benjamin West, his fellow-townsman of an earlier day; how it colored all his after career and biased him for what was called "historical painting" and made him a leader of his day in the land of Reynolds and Gainsborough and Constable and Lawrence.

But this voyage of discovery was, perhaps, the outgrowth of other instincts than those of art, for the eternal masculine had, before this, met the eternal feminine and in seeking his fortunes up and down the world he was to learn how to lay the foundations of a home as well as to find a broad base for his artistic career.

At the house of Robert Pearsall Smith and his wife, Hannah Whitall Smith, in Germantown, a suburb of Philadelphia, young Richards had met Anna Matlack,

WILLIAM T. RICHARDS
FROM A PHOTOGRAPH TAKEN ABOUT 1855

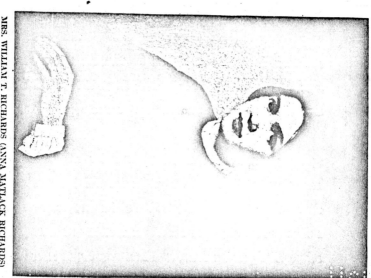

MRS. WILLIAM T. RICHARDS (ANNA MATLACK RICHARDS)
FROM A PORTRAIT BY WILLIAM HENRY FURNESS, 1862

an ardent, intellectual Quaker girl, who even then had written dramas and published verses. The young people were a part of the group, literary and artistic, that the Pearsall Smiths attracted to their hospitable house, and it was out of the association thus formed that they came to know each other better and to prize each other for likable traits.

Thus, before the young painter went to Europe, they were engaged to be married, though they had agreed to withhold the news from their friends, and concerning this romantic episode Miss Bridges says: " It was their mutual interest in Browning and Tennyson, and all the poets of that day, which drew them together "—a fine start for a household of ideals such as found embodiment in the tranquil home to be.

Its beginning was not long delayed—for on June 30, 1856, very soon after Mr. Richards' return, they were married by Quaker ceremony; not in the home of the bride, because the distaste for artists still pre-

vailed under the austere rooftree of Dr. Charles French Matlack, but in the house of the painter's loyal friend, Ellis Archer, in Philadelphia.

The honeymoon was spent in the Wyoming Valley, Pennsylvania, and one of their labors of love during those first months of happiness was the composition and illustration of a manuscript volume of poems for their friend, Hannah Whitall Smith, who had brought them together.

But these were hard times; there was little or no demand for pictures because of the great panic of 1856, and the wolf had to be kept from the door by evening work on designs for chandeliers for the always friendly firm of Archer & Warner. The busy artist did not return to the designing room, and still kept the precious hours of daylight for his own work out-of-doors; but the evening labor gave essential help in tiding over critical months.

For about a year after this the family lived in Phila-

delphia, where their eldest son, named for the friendly Mr. Archer, was born on April 30, 1857, and a little later they moved to Germantown, probably by May or June, 1857, and lived in Church Lane, near Mill Street, for nearly two years.

It was not until the latter part of 1857 or 1858 that the work on gas fixtures was wholly abandoned, and the self-reliant young art student pushed out for himself. Hardly can we conceive in our period, when native art receives some patronage, the boldness of such a step in the Philadelphia of 1858. The early seventies developed in young men a restlessness for other ideals than those of trade or the professions. The exodus to Europe began on the heels of William Hunt's return to Boston from France and was inspired by the stimulating essays of Earl Shinn. But this was a dozen years later, and that dozen years was as hopeless as the Valley of the Dead Sea. The city of the Quakers was drab and grim and tasteless and respectable and the chance for

a brave youngster who took his fate in his own hands was as one against thousands.

The English tradition prevailed without the English motive. Dunlap has told us in his "History of the Arts of Design" that the English of an earlier day looked upon Art as beneath an aristocrat; in the Quaker town, painting was an unhallowed thing fit only for the non-elect.

But Mr. Richards had stuff in him that would have overcome even greater discouragements. He was born for achievement and, without the physical power for overcoming natural obstacles, he had the grit and the genius for surmounting those of convention. He was a character, and if equipped and called, he would have gone his independent way, as Mungo Park did, into unknown Africa, or he was prepared to break down barriers of narrow habit nearer home.

On June 7, 1858, a second son, Charles Matlack Richards, was born, and in that same spring the family

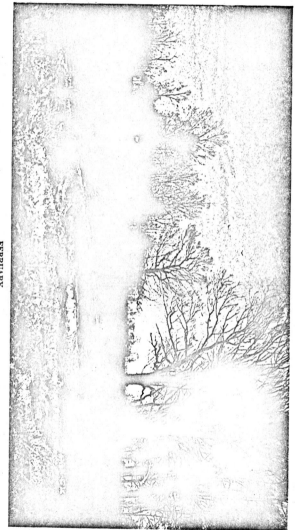

FEBRUARY

moved into the Mehl Cottage in Germantown. In spite of growing responsibilities and the total lack of capital, the young painter kept alive the courage of his convictions and painted that summer only one picture— "The Tulip Poplar Trees." It was a wonderfully detailed study, as all his work was of this period, and that he valued afterwards what he then produced was shown by his buying back this canvas as well as the earlier "Blackberry-bush." Both pictures still belong to his family.

These were the years when he laid the foundation for his unerring draughtsmanship, and the risks he took to acquire it were richly justified by the event.

Afterwards, if any aspiring young artist asked him, "How shall I learn to paint?" his answer always was, "Learn to *draw!*" Unlike some advisers, he took his own advice; and the number of his careful drawings which are still preserved is little short of marvellous.

Concerning this time, Miss Bridges writes: "In the

year 1860 I went to Philadelphia to study art. Mr. Richards, who was ever ready to render help, especially to women, kindly proposed my coming to paint in his studio, where there were then some half-dozen pupils —the younger Lambdin; Bispham, the animal painter; Arthur Parton, and two or three ladies. It is from that time that my friendship with Mr. and Mrs. Richards began. The summer of 1860, which I spent with them in a cottage in Bethlehem, Pa., was a very hard one for them. In the terrible excitement of the first year of the war there was no demand for art. He was painting out-of-doors the largest canvas he had ever painted directly from nature and struggling with the difficult problems of it, while he kept an eye on his two little boys, who always accompanied him."

Another close friend of this period—indeed, his chief patron—who has already been mentioned, was Mr. George Whitney. Every man of genius has had his Maecenas. Heaven seems to watch over her chosen

children, and no doubt Mr. Richards owed much to the taste and liberality of this greatly prized friend. Thus, in speaking of the pictures which he painted for Mr. Whitney, he wrote: " Most of them were selected from the studies of each year, and it was the pleasantest part of the season to submit to him the results of the summer work. His refined love for nature made his cordial appreciation an incentive and a reward. The drawings became, as it were, the expression of mutual affection, and it was to me truly a labor of love to make sure that he had the best I could do."

The summer of 1860 was marked by the production of the already mentioned " Blackberry-bush," and when the season at Bethlehem was past the family seems to have returned to the Mehl Cottage in Germantown, and in 1861 they moved to a cottage at the corner of Coulter and Greene Streets, where they stayed about two years.

In 1862, the oldest daughter, now Mrs. Eleanor French Price, was born, who possesses not a little of

her father's talent, and in 1863 they moved to Market Square and Mill Street—a quiet, odd corner which always seems to me a fitting frame for that old fashioned family. In 1865, they moved to No. 9 Penn Street, a large stone house next to the place of Mrs. Richards' father. This was the first house which the advancing young painter owned and he held it for twenty years.

Now, another daughter was born, who died in infancy, and in the next year—1866—Mr. Richards took his family to Europe, spending the winter mostly at Darmstadt and Dusseldorf. This is a significant date because it denotes that Mr. Richards had heard the call of Europe earlier than his fellow craftsmen and he must have been amongst the very first of the younger men of his time to go. His earlier visit had been one of observation, but now he was intent on the study of new theories. It was a progressive step and an adventurous one at that date, before the allurements of France had begun to act, and when only Chase and

Duveneck were contemplating like exodus from other American cities. A flying visit to Italy was also squeezed into the few months of study, and in the middle of December, 1867, they sailed for home on the *Fulton,* the last trip across the ocean of a paddle-wheel steamer.

One of the children describes this voyage vividly:

" They had from the first a very severe voyage, and as they approached New York, after nearly two weeks at sea, such a terrific snow storm came up that they had to put to sea again, without coal and leaking badly. To make matters worse the decks were coated thickly with ice and one paddle box was smashed. The wreckage was cleared away so as to allow the paddle wheel to revolve only with the greatest difficulty. Everyone on board, including the captain, almost gave up hope, but the ship pulled through safely and staggered into New York after a voyage of seventeen days." Among the fellow voyagers on this exciting trip were Mr. Samuel

P. Avery, the New York picture dealer, and his family and the congenial friendship made at that time with this generous and intelligent man was a source of pleasure and encouragement through all the rest of Mr. Richards' career. In yet another way this remarkable voyage greatly influenced his subsequent life. It was then for the first time that his mind fully realized the majesty, power and beauty of the sea, and this impression, deepening with the years, led to the memorable pictures we all know so well.

A month after this, on January thirtieth, the son who was destined to attain the most notable distinction, was born. This was Theodore William Richards, who is now Professor of Chemistry in Harvard College, a great discoverer in physical science and recently exchange professor at Berlin. His birth took place in the house of his grandfather, Dr. Charles F. Matlack, because Mr. Richards' house, next door, was still rented.

From now till 1878 the winters were spent in the

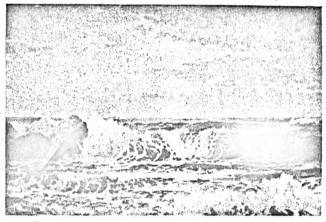

BREAKERS NEAR THE DUMPLINGS, CONANICUT, R. I.

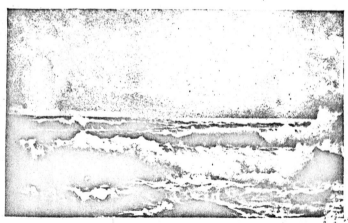

A REEF NEAR NEWPORT, R. I.

Germantown house with excursions in the summer to various places, and after this period began the visits to the seaside, at first to Cape May and then to Atlantic City, which have left so deep a vein in the work of the painter of the ocean.

During these years Mr. Richards devoted much time to the study of the technique of water-color, using both transparent and opaque color, and both white and colored paper. Charming and delicate drawings were made in great number, many of them having been purchased by his beloved old friend, Dr. Magoun, who upon his death presented a large collection of them to the Metropolitan Museum in New York. In the course of this work he evolved a somewhat original technique of painting large landscapes after the manner of Turner's "Rivers of France," in body water-color on the coarse, gray paper used at that time for lining carpets, which cost but a few cents a yard—and he was fond of saying that he got his paper so cheap that he could af-

ford to use more water! One of his colleagues tells us that: " they were very difficult to execute, and their excellence depended entirely upon his knowledge of the nature of the changes which drying produced in his colors, for they looked entirely different wet and dry. But many of them were remarkable pictures." Afterwards he returned almost wholly to the use of transparent color on white paper, and gradually developed unusual facility in the vigorous and sympathetic handling of this fascinating medium.

It was not until 1874 that the family rented a house in Newport, R. I. But in the next year Mr. Richards bought a place there, on Gibbs Avenue, which he kept for seven years. Meantime, in 1870, the daughter named Anna Mary was born—now Mrs. William Tenney Brewster—whose talent for design is a conspicuous token of the hereditary trait, and whose successes in England are remembered by those who knew her in the circle of Watts; and in 1871, Herbert Maule Richards, now a professor at Columbia College, was born.

In 1878, the family spent two years in England, laying foundations on those coastwise cliffs which led to the impressive canvases of rocks and surf of later days. There was a brief stay in Paris, too; but cheerful winters were spent in London, and the summers passed at various villages on the south and southwest coast of England, and Professor Theodore Richards says that during these years his father learnt much about rocks, and the complex wave motion caused by a broken shore.

In October, 1880, the family came back to the Germantown house; and the next year saw the building of the house on the cliffs at Conanicut Island in Rhode Island, which was called: "Gray Cliff." This was meant only for the summer, when it is possible to paint outdoors on that wild coast. But the needs of the incessant student of nature induced the exchange of the Germantown house for a large farm six miles from Coatesville, in the Chester Valley, Pennsylvania, where landscape could be overtaken in its more surly moods of

autumn and winter. For some reason Mr. Richards was curious about Mt. Tacoma, and in 1885 he took a trip to the Pacific coast to see it. If two or three large paintings of the mountain are excepted, no visible results to his art seem to have followed, as he went on in his accustomed pathways, holding his homes intact in Chester Valley and Conanicut until March, 1890, when he bought a cosy, homely house at an angle of one of those pretty Newport streets that go nowhere but to your own front door. This he alternated with "Gray Cliff" and with seasons in Europe between 1885 and 1890. He would disappear for a time to come back laden with canvases and a smiling and genial vitality which made his welcome glad and warm. He rarely spoke of his absence, sometimes to point an anecdote or explain a picture; and I remember, once, how he brought back a series of bewitching water-colors trellised all over with roses, of a country house in England and its lovely court-yard, where he had been staying.

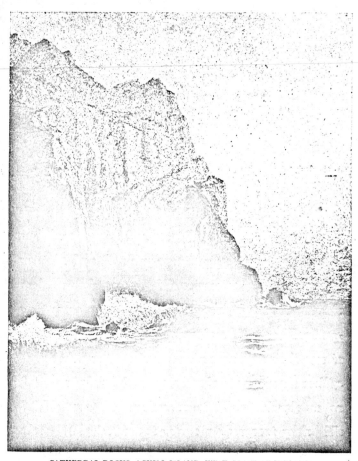

CATHEDRAL ROCKS, ACHILL ISLAND, WEST COAST OF IRELAND

joy plenteous books and talk. Mrs. Richards was overflowing with humor, and her original opinions were uttered in a quick, resonant, almost masculine voice, and with a delightful duck of the head and glance of the black eyes. She was of medium height, stout, and busy, and hospitable, and gave but little evidence in casual intercourse of the tremendous character and the fund of erudition within. She had previously educated those sons for college who have entered learned professions, and one of whom is celebrated the world-round for his discoveries in chemical and physical science; and she had not only presided over a household and reared talented children, but she was an unremitting force in her husband's career. Well can I still hear her amusing rally about the difference said to exist between the free, richly colored sketches and the finished pictures:

" I throw tables and chairs at William to make him paint broadly "—and then a laugh contagious and unforgetable.

It stood—a long, shingled house with a roof that tucked it snugly in, with porches overlooking the sea, and walks around about on the rocks, with the rich verdure of that coast running to the friendly threshold, and with its little detached gray studio in hailing distance as you approached it—it stood on a cliff made conspicuous from land and sea by a jagged white streak of quartz running up through the gray rock to the doorway. It looked out on the changeless blue horizon, on the curving granite coast, and on the dune-like "Dumplings," where an older generation had set the ancient fort of that name, now, alas, gone with "Gray Cliff." How well I recollect the somewhat rueful fun of Mr. Richards as he pointed to the adjoining "Marbella," where his old friend Joseph Wharton had built a massive wall in which great boulders were stuck at intervals. The artist's love of unhindered nature gave edge to his remark: "Wharton's Teeth."

Indoors there was comfort and the invitation to en-

He was usually reticent until animated by some lurking memory or the wish to make plain a conviction.

Among the summer journeys there were two rather adventurous ones with his wife, the first to the wild western coast of Ireland, when they drove over four hundred miles in jaunting cars, and another to the extreme north of Scotland, including the Orkney and the Shetland Islands. He found many subjects and much inspiration in both places. During the Scotch trip they journeyed for a while with Mr. and Mrs. Andrew Carnegie.

Then, the winters spent in the Channel Islands, especially on Guernsey, were also full of fruitful results in his art, but he always came back to Newport with a feeling of happiness in his own home which no foreign excitements or " Reiselust " ever dispelled.

But, in 1899, the tranquil flow of Mr. Richards' ideal family life at Newport was interrupted by the loss of " Gray Cliff." The United States Government wanted the commanding site for a fort, and there was no appeal.

But besides all her housewifely duties, she was busy with her well-furnished mind, and those who have had the fortune to possess the volume of her sonnets, called "Letter and Spirit," must acknowledge the existence of an original talent for poetry and an independence of thought and belief above the level of her day. Sonnet XVIII marks the poetic type, and her deeply religious, but quietly individual, point of view.

Alone in this dim summer light,—the air
Of ocean in the long sea-grass, and flight
Of shining mist above me, what delight
To seem a part of nature's self, and dare
For these brief moments to forget my share
In life's great tragedy of Wrong and Right
Before the listening heavens. On what clear height
Far from the inward voices, from despair,
Above the irretrievable years, thou reignst,
O Nature, fair as in the dawn of Earth!
Nor storms nor sunbeams ever reach thy soul;
And I, forever conquered, fight against
The inexorable limits of my birth,
And learn no wisdom from thy self-control.

BREAKERS AT BEAVER TAIL, CONANICUT ISLAND, R. I

And turning from these introspective sonnets, what a contrast to open the pages of her buoyant and self-forgetful fun, which was not so much an imitation of the " Alice " books as a continuation of them. She had absorbed and given out to her children all that " Alice " held; and, wanting more, she made it—made it with an invention and gaiety which ought to have won the heart of " Lewis Carroll " himself. The illustrations by her daughter, Anna, are another evidence of the gifts the mother fostered in that busy and happy household.

Indeed, Mrs. Richards is so much of a part of the intellectual career of Mr. Richards, so inwoven in his fibre, that to describe her is further to personify him.

But even so rare a flower, so beautiful and difficult of growth, as a home like his and hers, must fade. It seems a waste of nature to rear such associations, such delicate and fragile ties, mingled of high aims and affectionate hopes, fair counsels and firm convictions, and then let them dissolve. How can a delicate creation like that arise again in a world which opposes simplicity

and makes light a moderation? Nature, I repeat, seems prodigal of her best fruits when she allows a hallowed and tranquil fireside to fade into forgetfulness.

Mrs. Richards died at Newport in November, 1900, and from this separation Mr. Richards never quite recovered. He painted and travelled, even to the bleak north coast of Norway, but his home on the rocks was gone and she was gone who had embodied its spirit in herself. He was lonely and growing old, and though his household was made cheerful by grandchildren, and his daughter, Mrs. Price, watched over him tenderly, he seemed, as I remember him then, to ebb into pathetic old age.

Of those days there lingers in my vision one characteristic glimpse: of the dark slouch hat covering the silvery hair; the black-coated, slight figure; a wind-blown umbrella and the quick insistent step as he left me from a trolley-car and pushed on into the rain. He was thinly clad for that tempest and I urged him to

stay with me. We were returning from a journey East, but he had a sister in Philadelphia whom he wanted to visit and his decisive mind was made up. He disappeared through the narrow brick street and I had no other sight of him for months. Then, he was old and weary and sad.

He died in the Newport house on November 8, 1905, and was buried at Laurel Hill, in Philadelphia.

III.

What was there in the sea pictures of Mr. Richards that picked them out from all others for remembrance; that made it easy for the most critical layman to say with conviction: " That's a Richards "?

In the first place they were frankly true. He painted what he saw. He made no effort to put into the picture what was not in nature.

No sensational composition; no strained effects of light and shade; no affected accent of any sort were in his mind. He wanted the observer to see what he had seen and he set it down with the sense of proportion and the eye to justness which were his central traits of character.

Perhaps it was this recognition of simplicity as the touchstone of the artist that gave Mr. Richards his bias for Wordsworth. Those who know Wordsworth's epochal preface to the " Lyrical Ballads " will under-

stand the affinity. The great English poet and seer laid down the law that for over two generations has governed English poetry. There was to be no more artificiality, no more theatrical appeal, no more rhetoric and antithesis and unnatural posing. The mellow English speech was to return to the nursery and it was to tell tales of plain life, unvarnished nature, simple reality.

This was the preference of Mr. Richards as an artist. He looked out at nature in a reverent spirit. He had instincts to copy and to interpret. He never felt the need to add adornments of his own or to force his personality into the transcript. His was not the fame at stake, but nature's. He never thought of himself. He was not a high priest in theatric robes; but an humble worshipper. Why should he be supplying additions or trimmings to a sight already so overpowering in its beauty and mystery? If he could get the facts stated in a language every eye could recognize—that was a great thing, that was the duty nature was fulfilling

through him. He was to see justly and report accurately and the soul within him would make pictures if he only kept his head level and his eye alert and bent to his task.

Without a soul to respond to something larger in nature than the detail, this faithful copying would, of course, result only in an accurate photograph. There would be a transcript, with the spirit omitted, as in the case with so much that is called art—a semblance of form without its moving principle.

But it was Mr. Richards' high merit as a man and as an artist that he brought to this task, so devotedly and lovingly performed, a soul that infused life into the work; that he lent it his own devout and tender love of beauty and his veneration of nature's living impulse. He copied what he saw with minute fidelity; he was led to copy because he loved what he saw and recognized the divine light shining through its surfaces; but if he had not also brought to the worship of nature the

SACHUEST BEACH, NEWPORT, R. I.

"WHEN THE FLOWING TIDE COMES IN"

soul which stood for him, and him alone—his penetrating individuality—he would not have made works which all his contemporaries acknowledge as embodiments of truth and beauty when they say: "That is a Richards."

And this suffusion of his art into himself was shown as well in his color. He was not at the beginning a rich or great colorist. If he had shortcomings in his talent, color was the principal of them. He had individuality and personal traits in his color as he had in all he did. This was another manifestation of the spirit's influence which made a unit of his work. All that he did stood for something distinctly emanating from himself. But color was not his strong point, as were fidelity and drawing and composition and selection. He was nearly always unerring in these, but in color he was sometimes perfect in detail, as often with that difficult under-side of a wave curving to a fall where the sudzy white mingles with the ineffable green; and again he would fail to give the freshness

and floating depth to a sky full of clouds, or the silvery gray of a long vista of New Jersey beach. He knew nature so well, was so much in her secrets, that he was alive to all her myriad beauties of tint and changing hue; but his paint did not always take on the magic of his model, tho' in pictures like that memorable one of the bare tracery of the trees against a winter's sunset his brush was dipped into tones that were not far from nature's own.

It was, indeed, characteristic that Mr. Richards should restrain himself in the use of color. His whole life was one of salutary restraint. He was half-Quaker in his treatment of the alternatives which life presented to him. He liked simple clothes, and plain surroundings; why should he not see nature in her simpler colors; or, when confronted with a choice, cleave to the subdued and quiet and unsensational? He had his own wise ways and he followed them whether they led from convention or not. He would no doubt have admired

Lumenaise or Ryder for glorious and precious color; no doubt he enjoyed the varied fashions in dress of France and Italy; but he did not adopt the one nor covet the other—he went, like the single-hearted gentleman he was, after his own leading and independently interpreted his own mind.

We are told that sometimes in speaking of his earlier work, he would call it monochromatic, and this was, in the main, a just criticism from a self-analysing spirit; but those also who have seen many of his last canvases must recognize a veritable " sea-change " in his variety and richness of color—not constant but occasional, and indeed sometimes implying that he too, like Thomas Hovenden and Alexander Harrison, had instinctively taken what was best, by compromise and adaptation, from the Impressionists. Indeed, he was glad to express his obligation to this modern school for help when he felt that he could well accept it; although he abhorred the prevalent neglect of careful drawing and inattention to

form and modelling. His always progressive mind was thus alert for what could add to his equipment even when he had passed into the sixties.

It was in drawing that Mr. Richards was a master. From the first this seems to have been implanted in him. I do not mean that it came instinctively; no such trait ever comes without work and thought. But the germ of correct vision and apt manual dexterity must have been born with him; and luckily he was gifted with a mind and a bodily diligence which brought that germ out and developed it to its limit. His patience and his diligence were, of course, essential to the full flowering of this faculty. He could not have drawn so masterfully if he had not studied unceasingly; but this is only saying that Mr. Richards was a marked man from the start, and if I make this clear in a loving attempt to do him justice I shall have done all I sought to do.

I have seen that other master of drawing, William

THE YELLOW CARN, KYNANCE COVE, CORNWALL, WALES

M. Chase, stand before a marine of Mr. Richards' and, lifting his stovepipe hat, with a low bow, say:

"I take my hat off to him. He's a master of drawing—I take off my hat——"

And if any one wanted to test this faculty of Mr. Richards' artistic equipment, after such authoritative statement, he need only look at the black and white reproductions of the varied marines and landscapes and notice how much they resemble photographs direct from nature; how true they are to the form, and mass and relative distance and aerial perspective of the world about us. This is what is meant by drawing, and only a draughtsman of genius can draw with paint in that faultless and fearless manner.

The sister-sense to drawing—indeed, the elder sister—is, of course, observation. Without keen insight and the patience to watch the processes of nature that abound in beautiful profusion about us, there is no foun-

dation for reproducing them enduringly with a brush.
What you don't observe you cannot describe or depict.
We have seen that this trait of unhurried and penetrating observation was one of those gifts on which Mr.
Richards built his life. He meant to see nature close and
see it whole, and he never faltered from the beginning
in this principle of design and drawing. He needed to
draw the movement and animation of breaking or surging waves, and he went to the best school in the universe, the surf itself. He found the picturing of the
sea a tradition established by Claude and continued
by Turner. Vague breadths and reaches of the shores
and the ocean were suggested by color and form, and
deep vistas of sunlight or cloud carried the eye away
from fact into the unreality of visions—beautiful, inspiring and masterly as dreams; but more in the nature
of "impressions" than those so-called of our time.

This rendition of the facts that Mr. Richards loved
he could not accept. For him, nature was supremely

beautiful only when it was true, and he resolved, with the spirit of his age upon him, to give up visions and seek the miraculous facts.

It is to illustrate this characteristic that I am going to quote a passage from one of the soundest critics of art we have had in this country, Dr. Alfred C. Lambdin, an old friend of Mr. Richards', whose deeply-based views never faltered in dealing with the artist's gifts.

" With that power of analysis which always distinguishes him he strove to ascertain the laws which govern the wave forms, and from that time for several years he devoted all his intelligence to the study of the sea. To him was given in reward that rare opportunity which comes to so few men, to do a new thing. No artist had ever before studied the wave motions in an exact and scientific manner, so as to understand the relations of one wave to another and of all to the undercurrents and the wind and the tide, and all those varied forces which make the water on one shore, or under

one sky, so different from the water on another shore or under another sky. This study was an arduous one. The facts must all be stored in the memory and the effect worked out by a mental process. To do this and at the same time add to the result of an intellectual process the vigor and robustness which comes from work done directly in the presence of the thing depicted was an impossibility all at once, and the earlier attempts were marked by a thinness and smallness of style, which gave great offense to the learned art critics. But no one could deny that the facts were for the first time accurately stated, and the effect upon the other painters of the sea was immense. It worked a revelation in the minds of the younger men; and it will never again be possible to make the world accept the old-fashioned wave drawing for accurate representation."

It would hardly be possible to estimate the number of pictures produced by Mr. Richards in his long and

ON THE COAST OF NEW JERSEY

CORCORAN GALLERY OF ART, WASHINGTON, D. C.

busy career. From the eighteen-fifties to nineteen hundred and five is a wide stretch—fifty-five years of ceaseless sowing makes a great harvest. But nobody could now trace all the work he did. We realize its extent by the examples known to each of us, prized dearly by their owners and held in many American cities publicly and privately.

If the many who own " A Richards " could be led to tell us of it, the record would roll up a great tribute to the genius and industry of one independent American man of thought and action in a day of apathy; and it would prove, some time, of value for the annals of a period in American art, rich in its formative influences toward a distinctive national school.

Of this movement, William T. Richards was a beginner and a leader. If we stand now for anything in art it is for the straightforward conveyance of facts. This is not the utmost limit of any art. There are ideals beyond facts and imaginative truths beyond ideals.

But no national art has ever begun at the top and grown backwards. Method must be learnt before the thing to be expressed and the thing expressed comes before imaginative excursions. Through these stages we have been going, and one of the surest and safest guides in method and expression was Mr. Richards. He had his own ideals, his own visions of grandeur in cliff and sea, he made his own adventurous way in the dizzy places of higher art, and he has left noble examples, poetic and uplifting. But his great merit was his painstaking application, his impeccable drawing, his humble and loving observation of nature, and his mastery of his art.

One of the lasting impressions of one's life is that scene at the Pennsylvania Academy of the Fine Arts, when it was in its glory and conferred on its old and honored pupil and Academician the highest award in its gift: the Gold Medal of Honor. At that dinner, where all the American artists of the time were grouped

amongst their works, he was acclaimed by his peers for his merits, and his modest emotions are never to be forgotten, his pleasure and his deprecating, appealing acceptance of recognition, so generous and so just.

His had been a long patient journey, traversing many ways of deprivation and many upward and downward paths. There were honors enough—at the " Centennial," in 1876, in Paris, and in Philadelphia at an earlier day; but this was the culminating glory and it came fitly at the end: a golden crown for his silver locks.